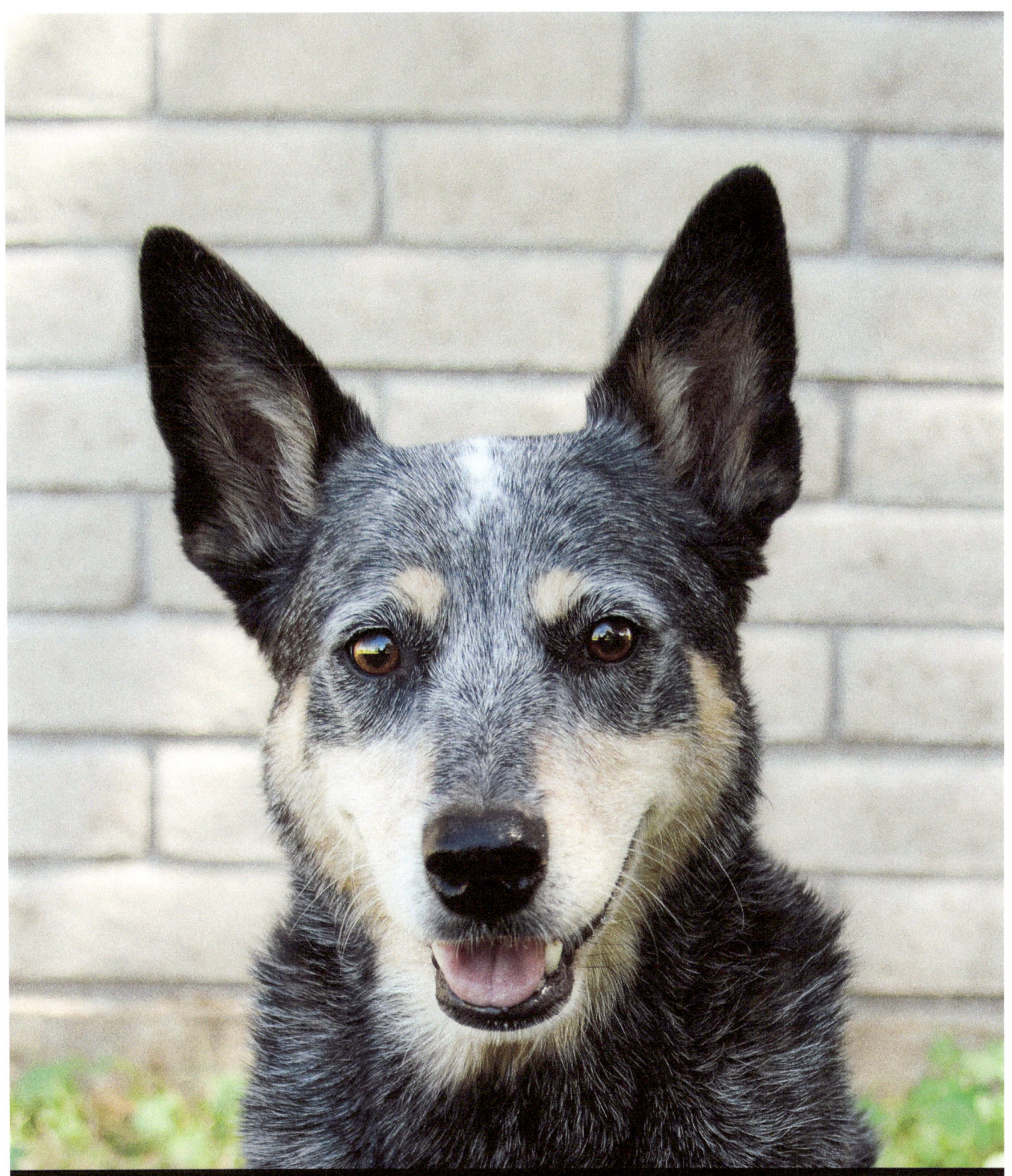

We are what we think. All that we are arises with our thoughts. With our thoughts, we make the world.

~Buddha

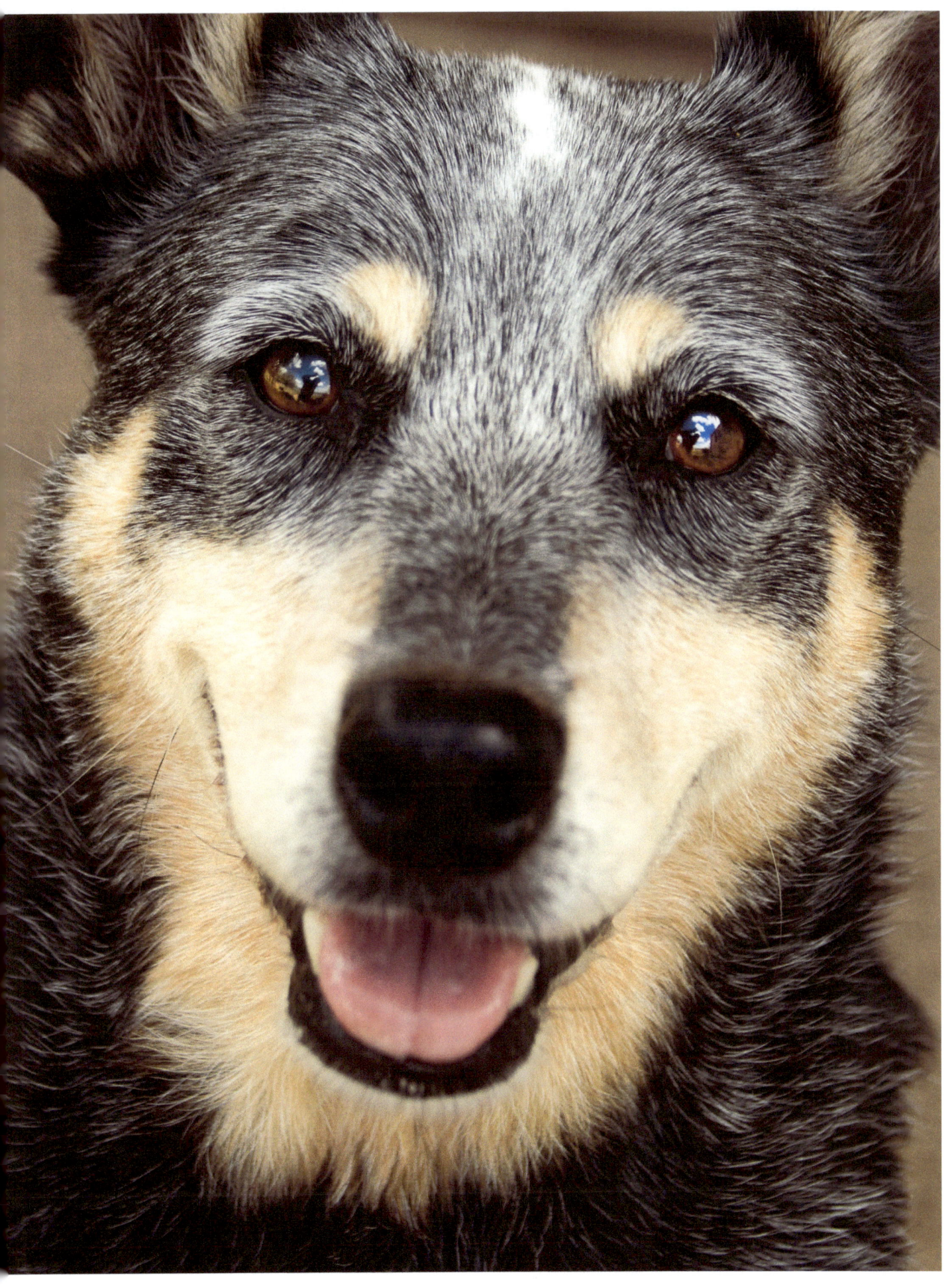

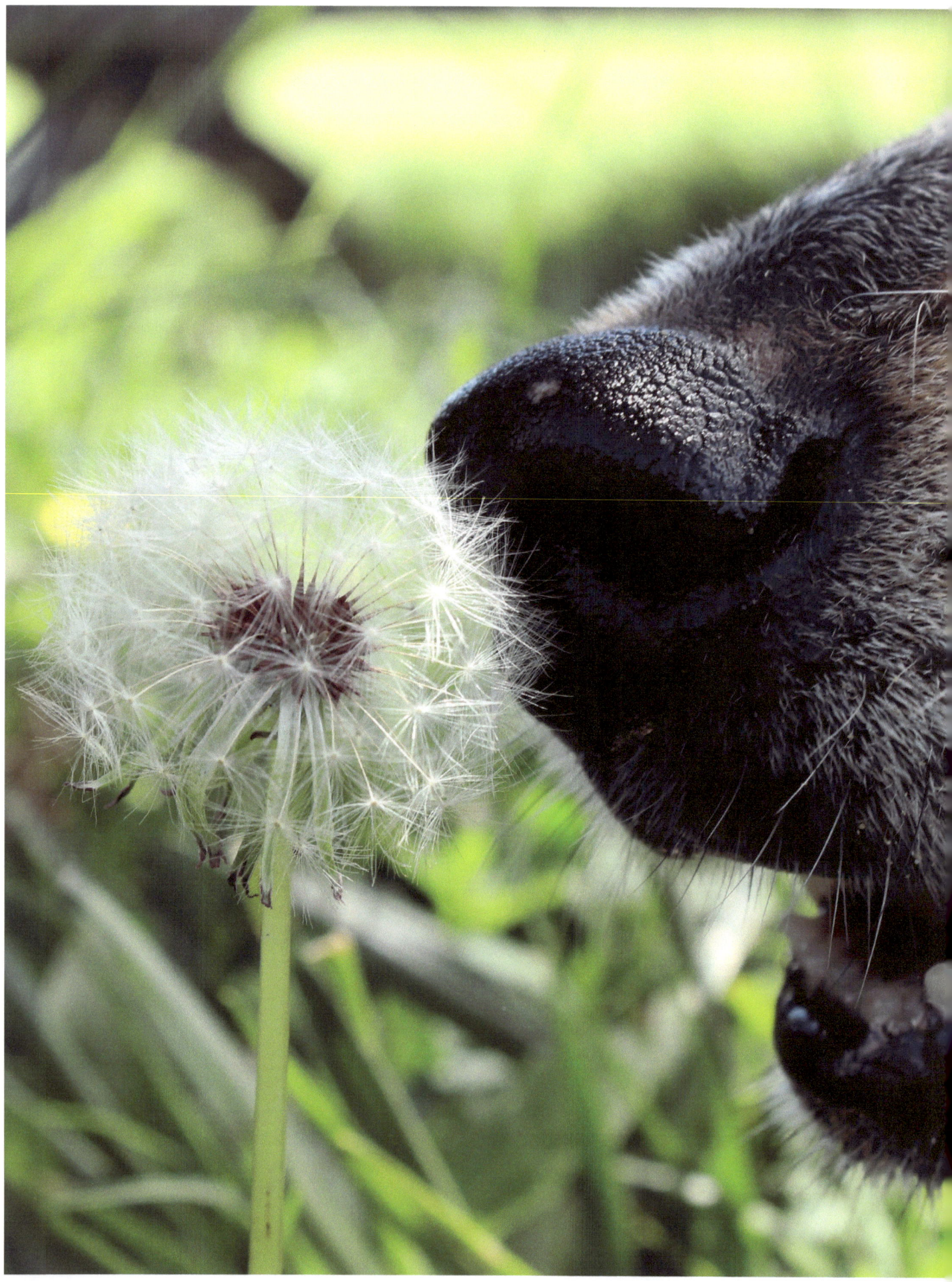

Remember to take the time
to smell the roses
and enjoy the moment

Listen with your ears,
not with your mouth

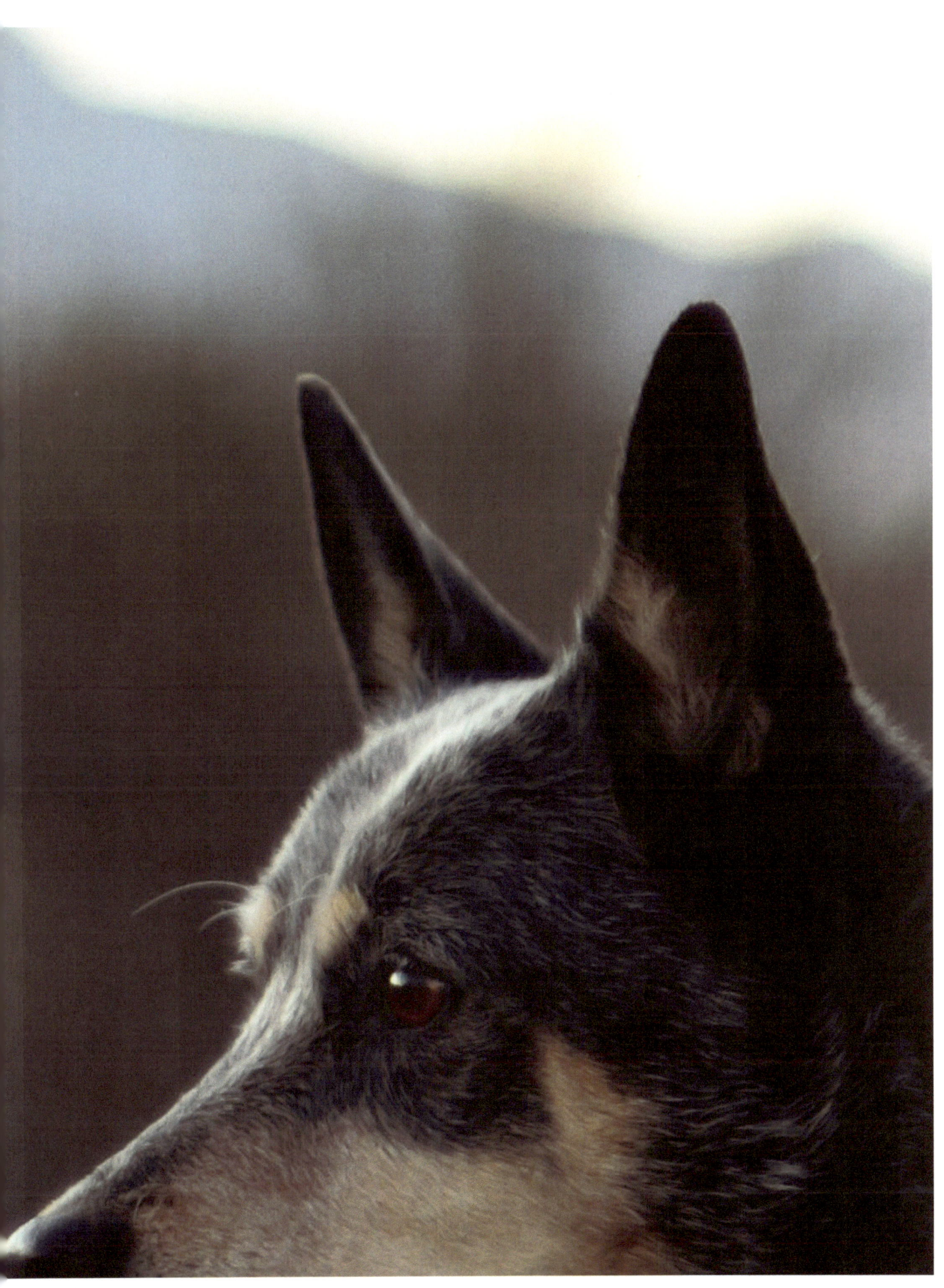

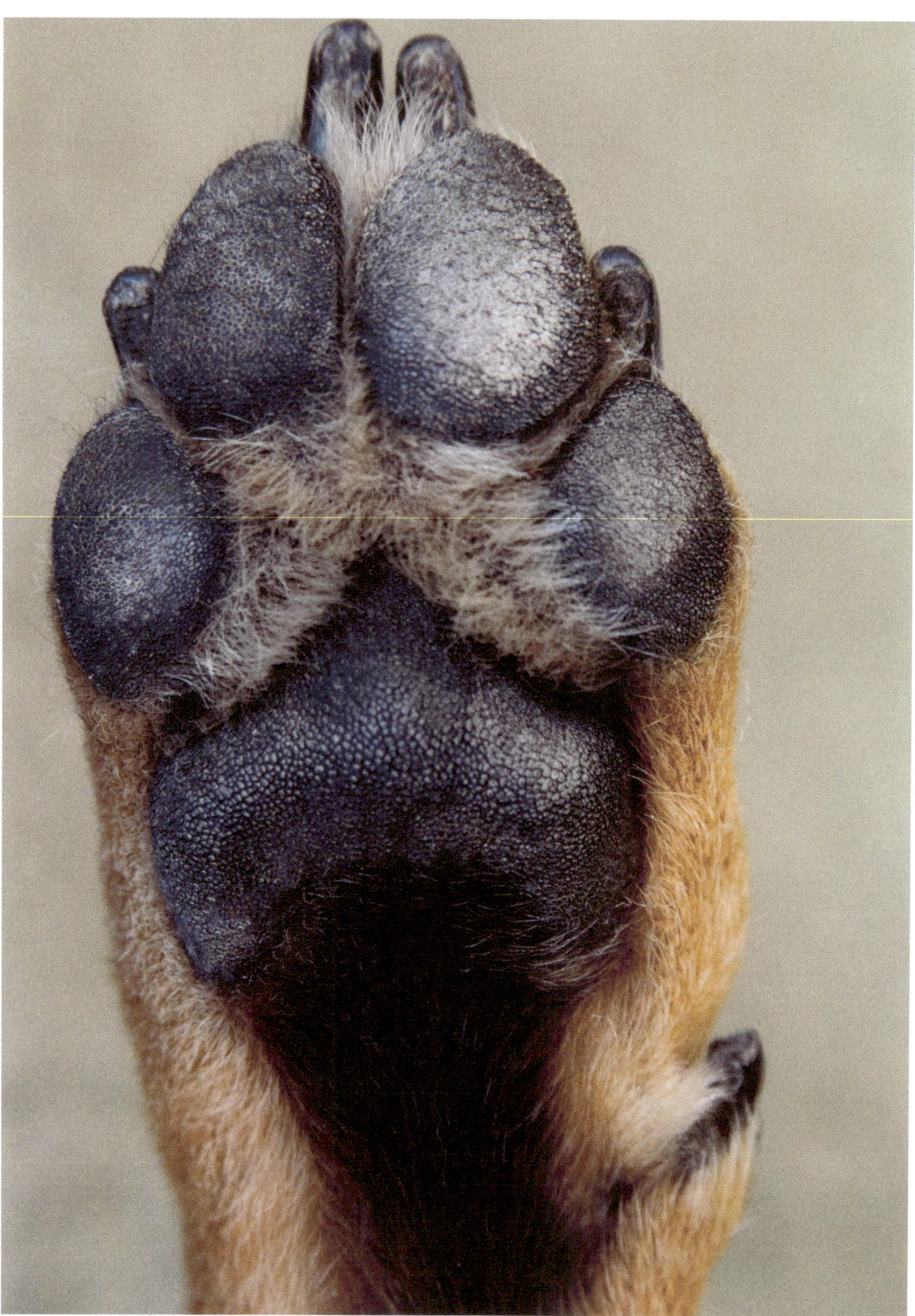

Never judge another until you have walked a mile in his or her shoes

Beauty
is in the eye
of the beholder

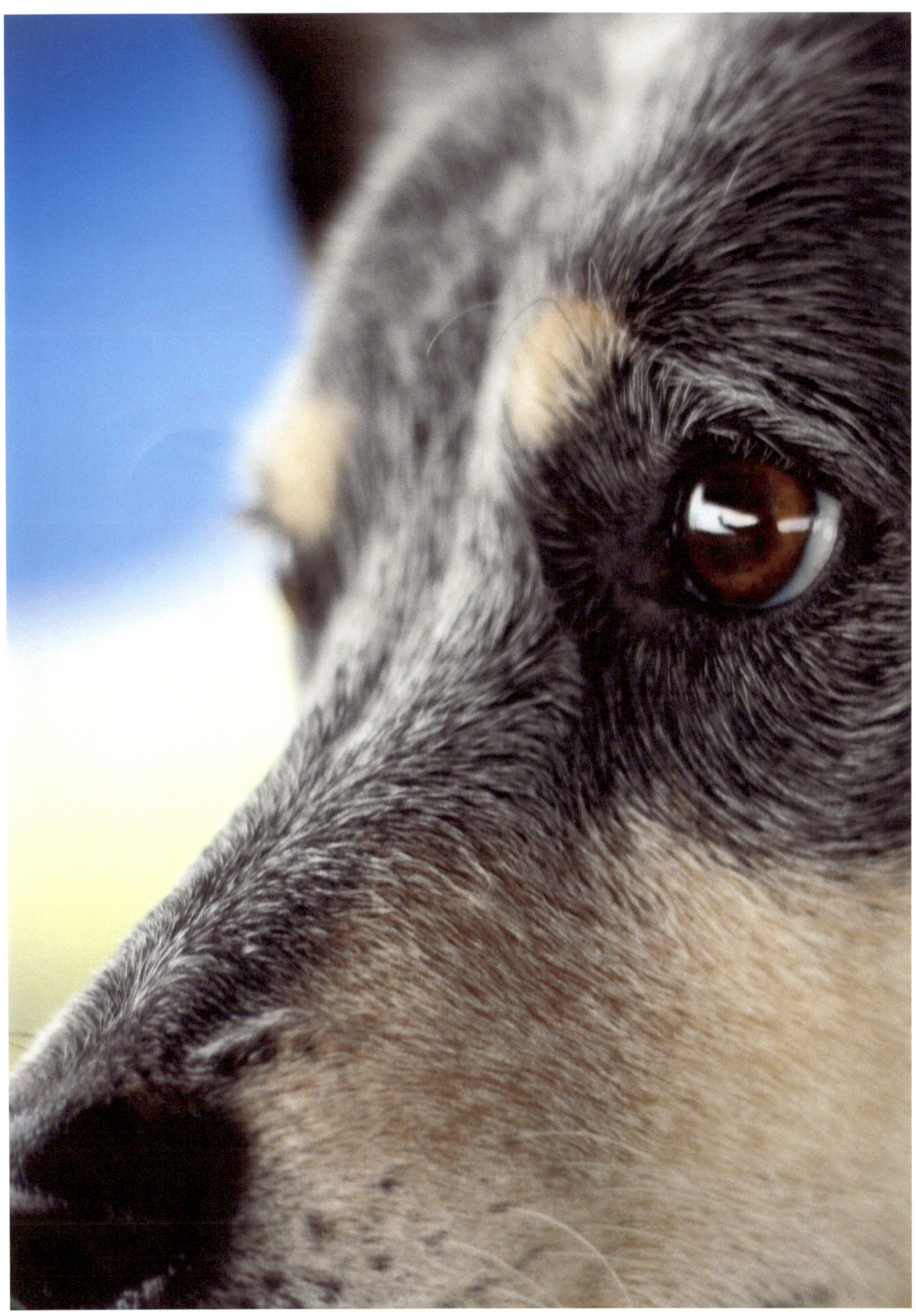

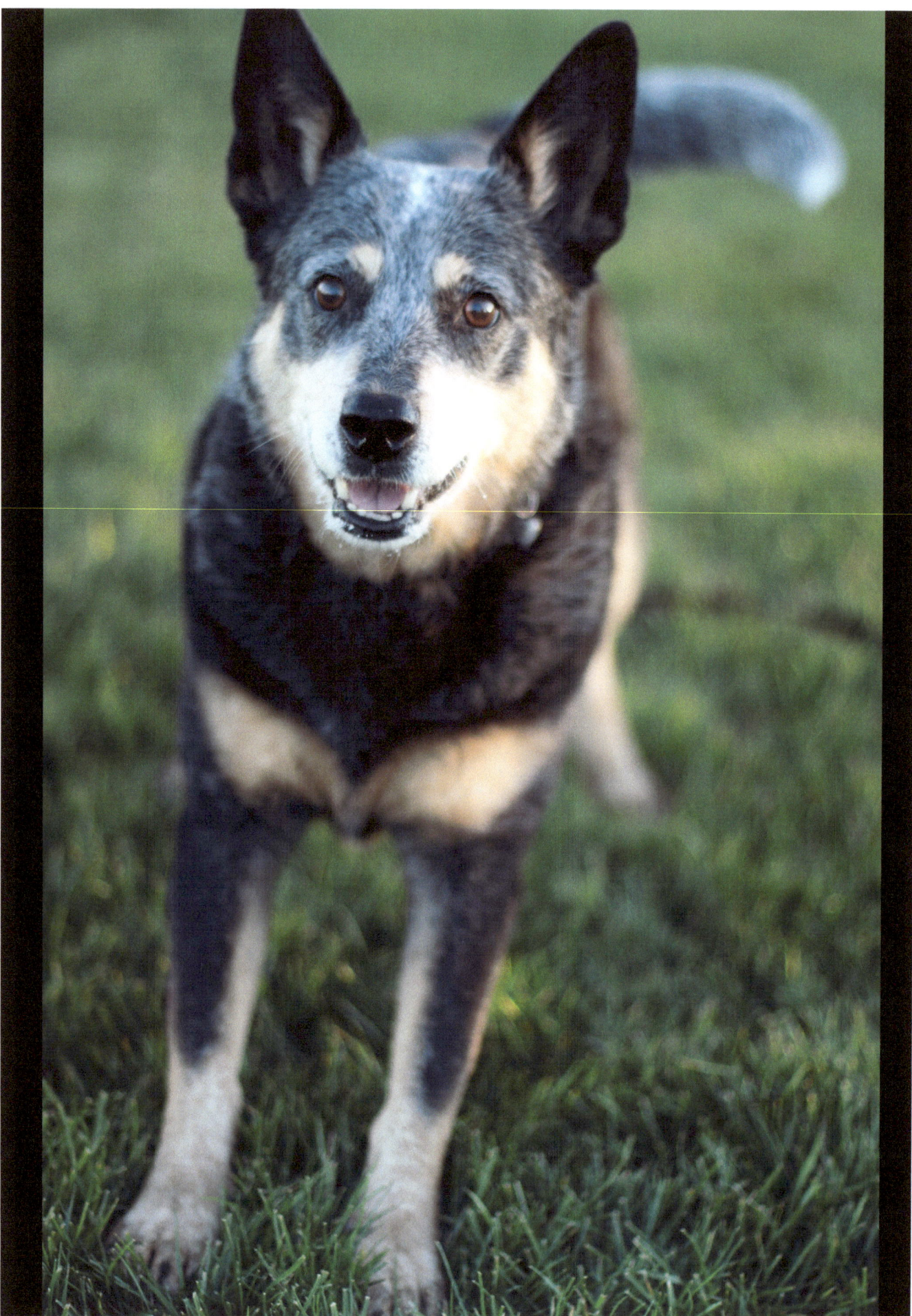

We do not stop playing
because we grow old;
we grow old
because
we stop playing

Never look down
on someone
unless
you're helping them up
~Jesse Jackson

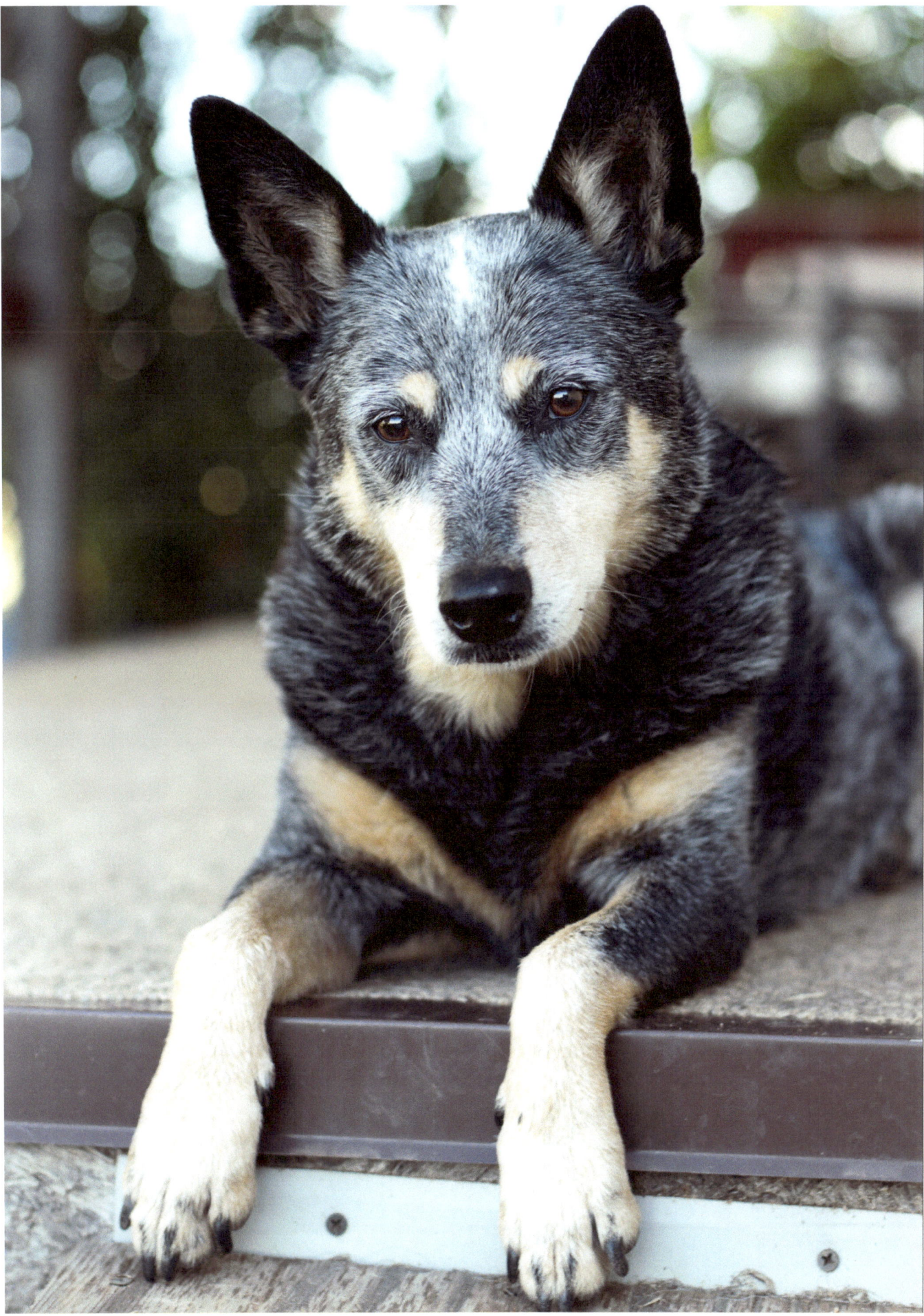

What lies before us
and what lies behind us
are small matters
compared to what lies
within us
~Henry David Thoreau

Too often we underestimate the power
of a touch, a smile, a kind word,
a listening ear, an honest compliment,
or the smallest act of caring,
all of which have the potential
to turn a life around.
~Leo Buscaglia

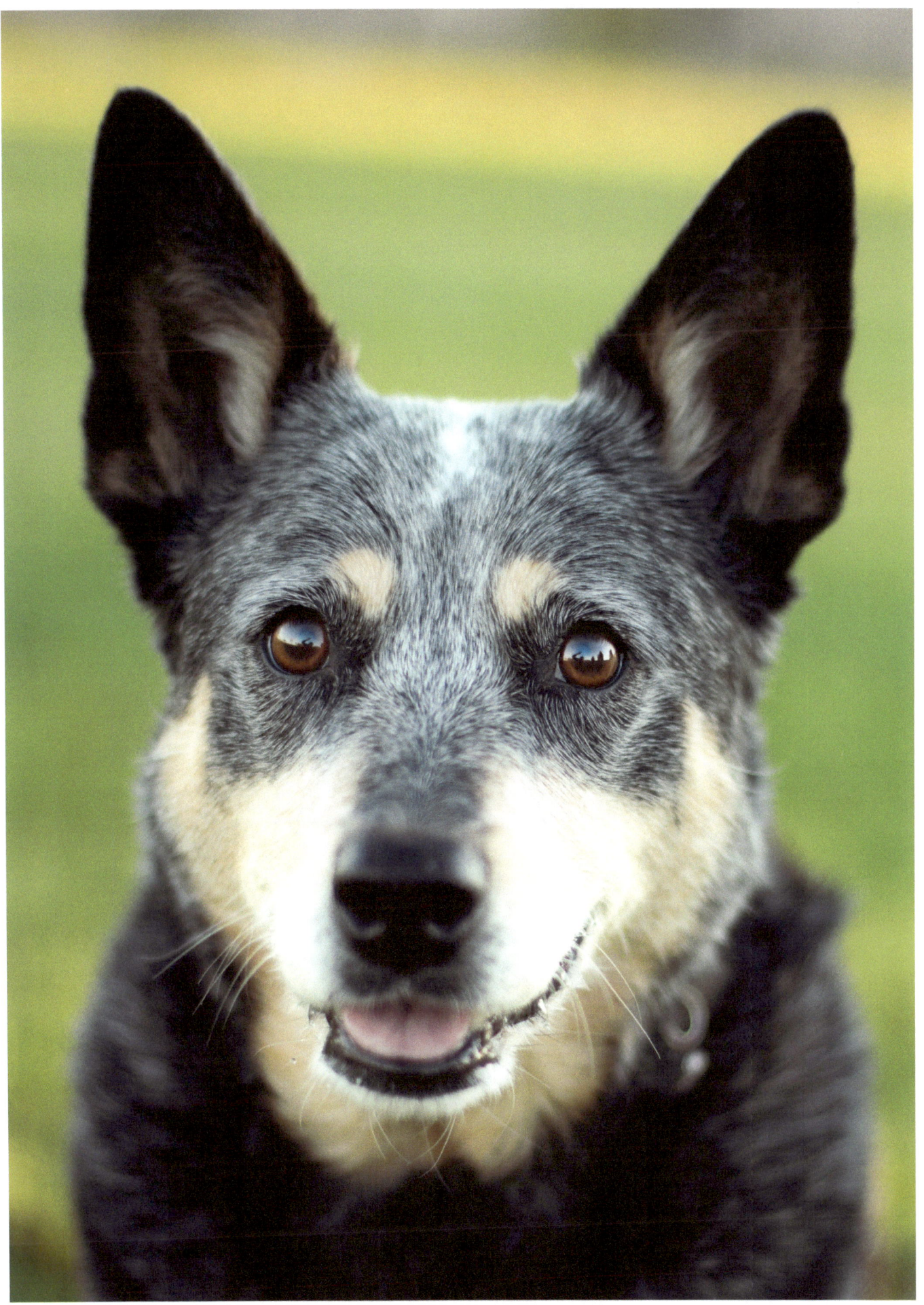

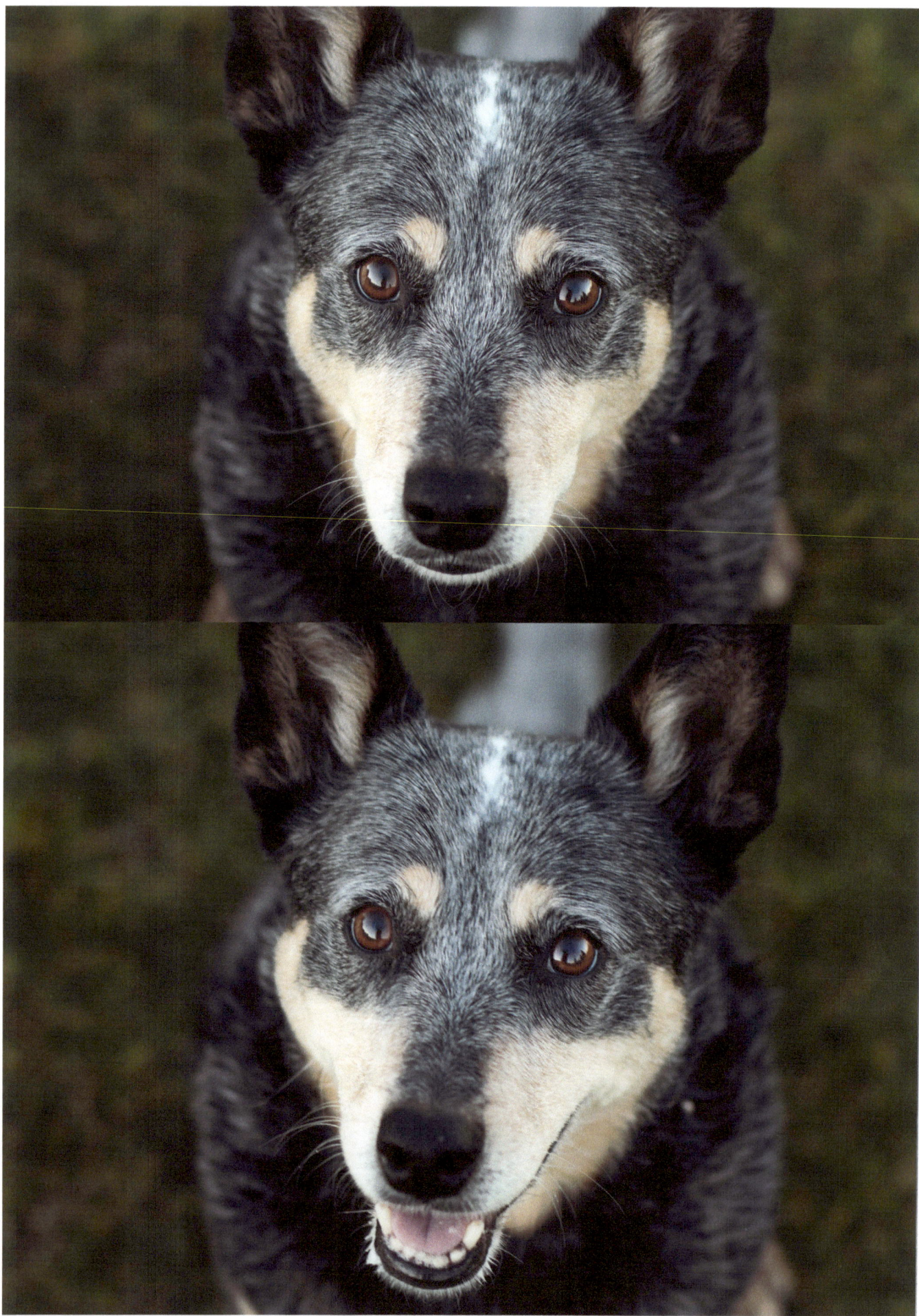

I have not failed 10,000 times; I have just found 10,000 ways that do not work
~Thomas Edison

Dance like there's nobody watching;
Love like you'll never be hurt;
Sing like there's nobody listening;
And live like it's heaven on Earth
~William Purkey

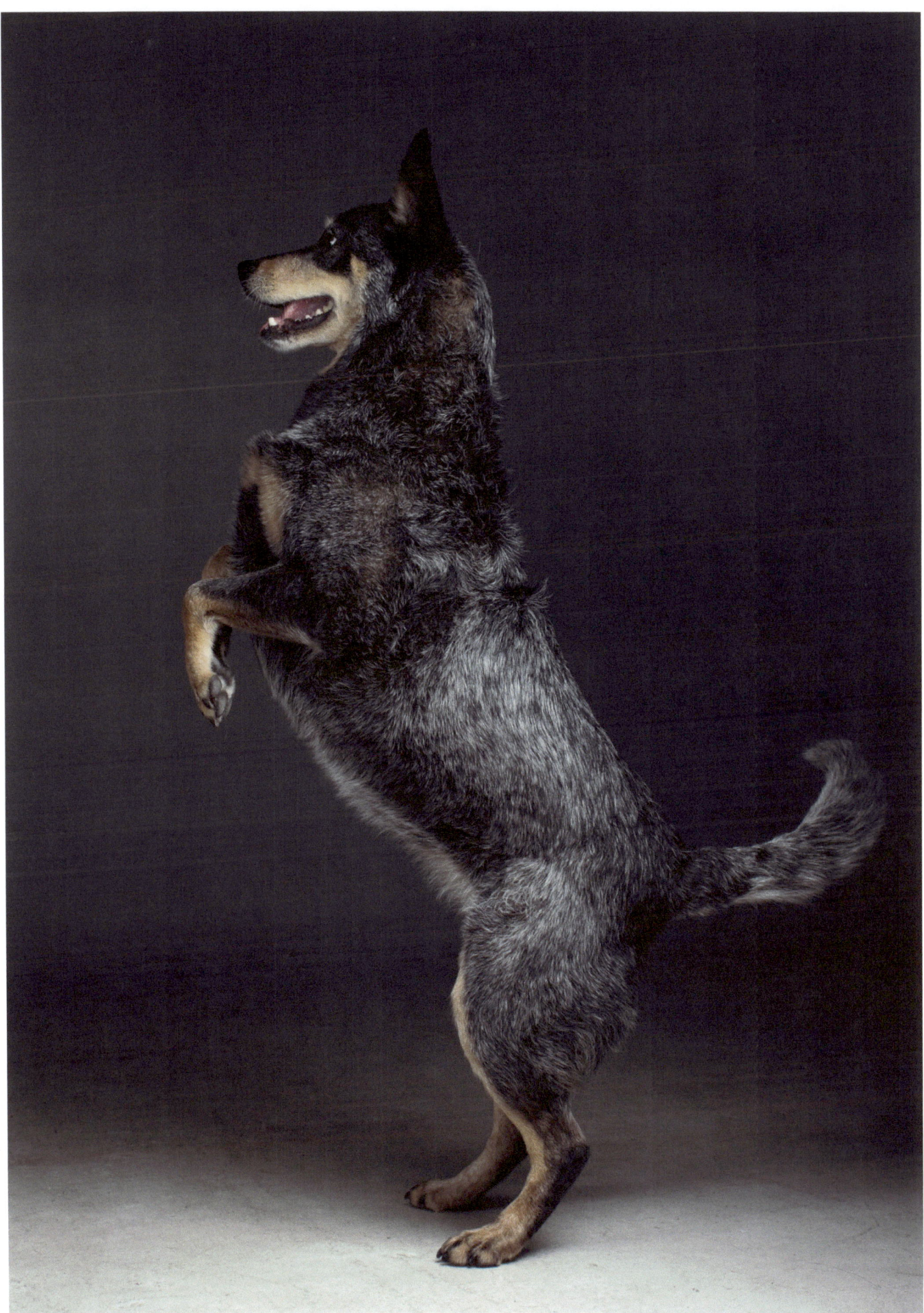

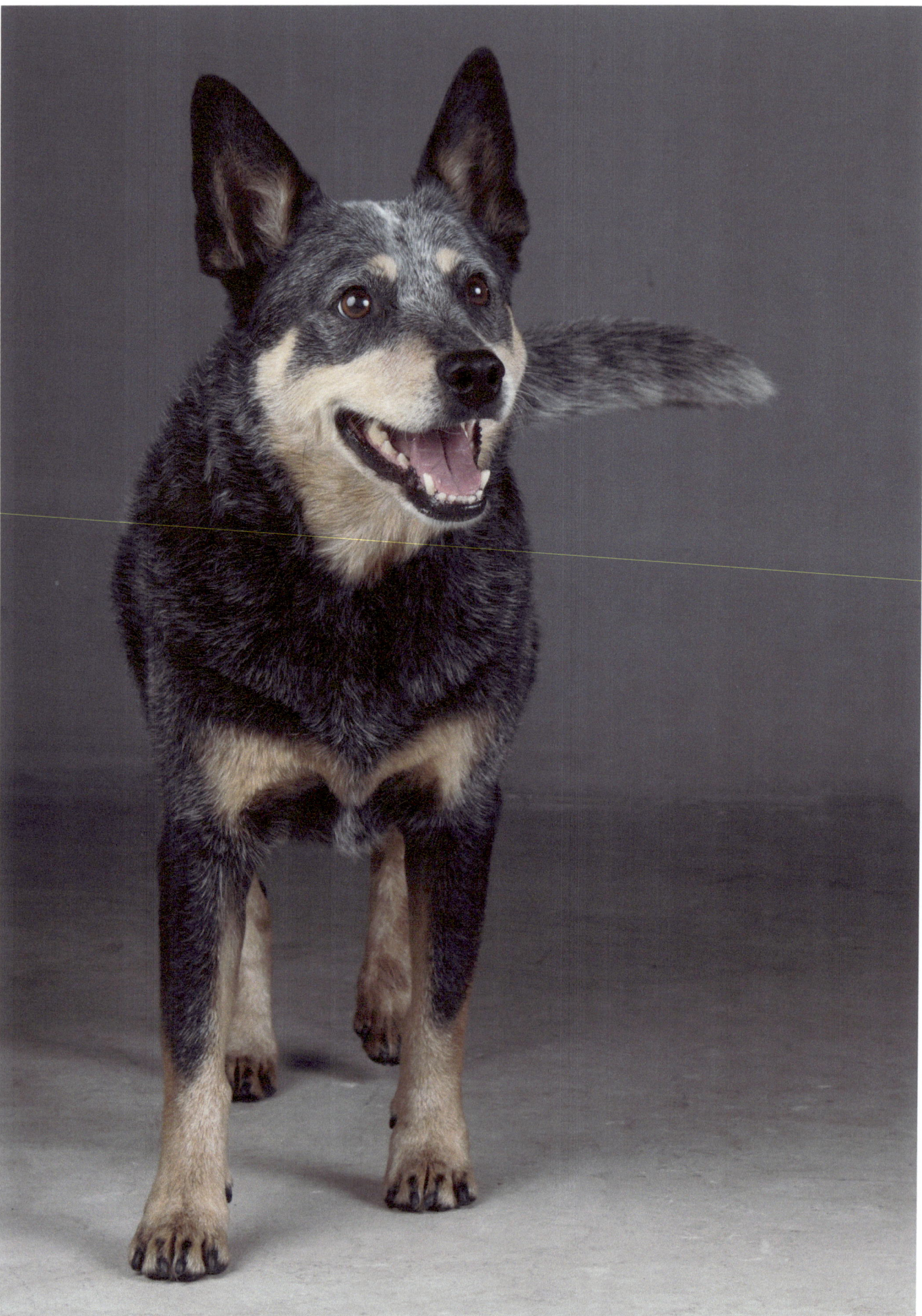

If you judge a fish
by its ability to climb a tree
it will live its whole life
believing that it is stupid
~Albert Einstein

It takes courage to grow up and become who you really are.

~E. E. Cummings

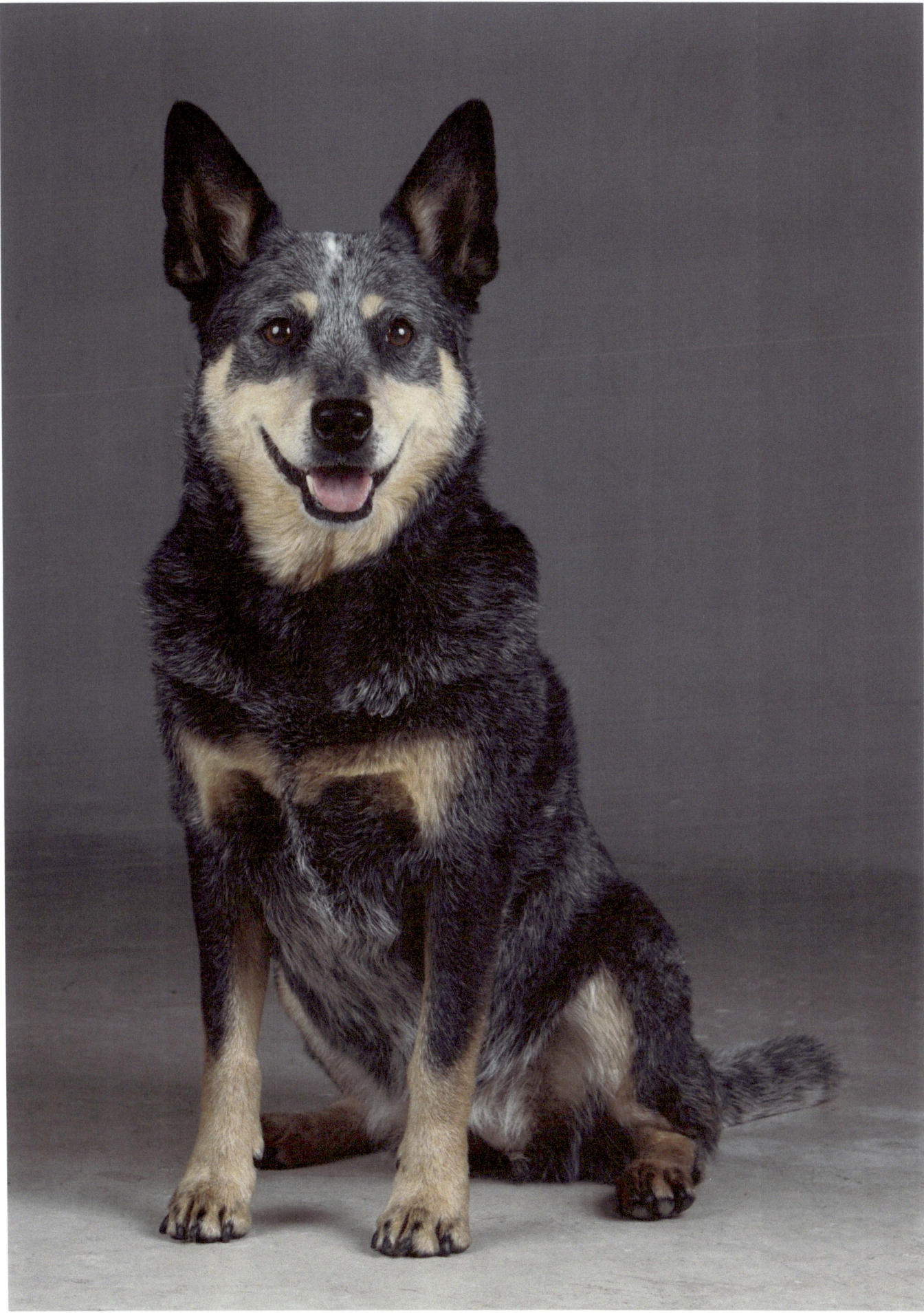

Live life to the fullest ~ Patrick Hughes

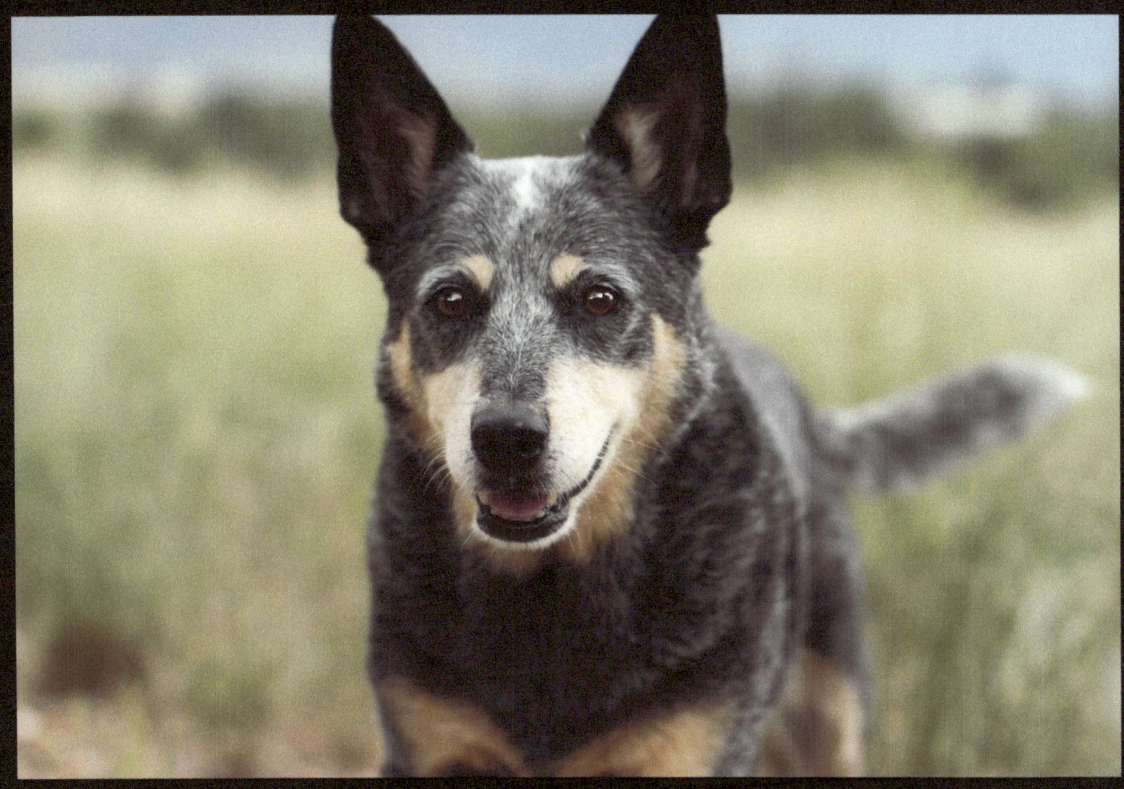

Websites

www.WindWolfPhotography.com

www.TiffanysDiamondDogs.com

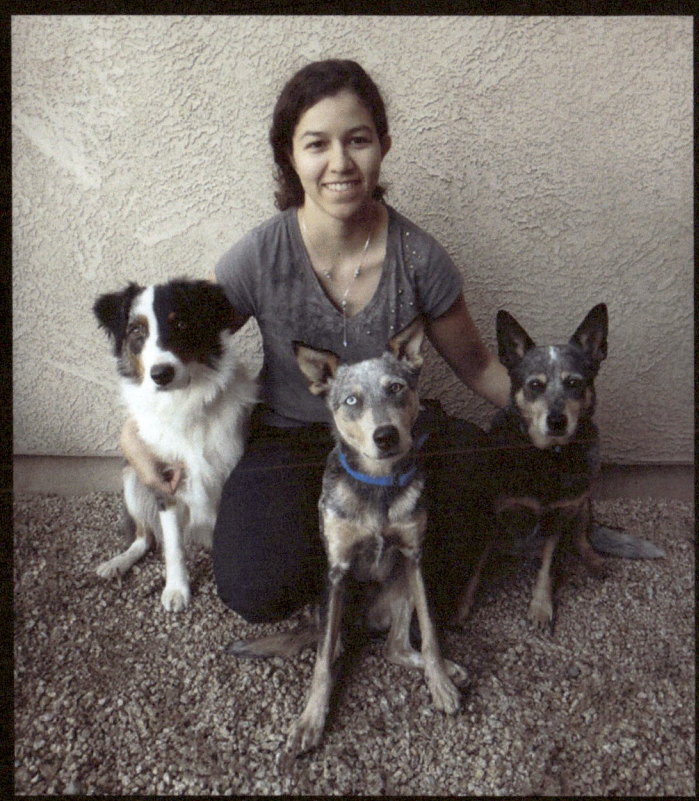

Tiffany with Bella, Terra, & Kronos

Author Bio

Tiffany is a Photographer, Investor, Blogger, and Studio Animal Trainer. She studied and received a Bachelors of Science in Photography with a minor in Business from Northern Arizona University in Flagstaff, AZ. She has her own photography business, Wind Wolf Photography, which is primarily focused on Commercial, Studio, and Stock photography for pet related businesses.

She also shares her life with two other amazing canines in addition to Bella-Kronos the CowDog Mix and Terra the Australian Shepherd. She enjoys going for hikes with her dogs, teaching them tricks, participating in dog sports, attending rescue events, and attending dog events.

www.ingramcontent.com/pod-product-compliance
Lightning Source LLC
Chambersburg PA
CBHW041303180526
45172CB00003B/950